Human Beings *and* Being Human

Human Beings and Being Human

JOSE ANTO

PARTRIDGE
A Penguin Random House Company

Copyright © 2014 by Jose Anto.

ISBN: Softcover 978-1-4828-3643-1
 eBook 978-1-4828-3641-7

All rights reserved. No part of this book may be used or reproduced by any means, graphic, electronic, or mechanical, including photocopying, recording, taping or by any information storage retrieval system without the written permission of the publisher except in the case of brief quotations embodied in critical articles and reviews.

Because of the dynamic nature of the Internet, any web addresses or links contained in this book may have changed since publication and may no longer be valid. The views expressed in this work are solely those of the author and do not necessarily reflect the views of the publisher, and the publisher hereby disclaims any responsibility for them.

To order additional copies of this book, contact
Partridge India
000 800 10062 62
orders.india@partridgepublishing.com

www.partridgepublishing.com/india

Contents

Sin Test ... 11
The Unaccountable Life ... 13
Belongings ... 15
Invention of God .. 17
Refusing Breathe .. 19
A humanist ... 21
Subordinated woman .. 23
Rapport .. 25
Shark and snail .. 27
Connecting Waves ... 29
Valuable possession .. 31
The Real Beauty ... 33
Invisible and indivisible ... 35
Unchanging Love ... 37
Emotions of Teens .. 39
Beneath Trees .. 41
Sacred house ... 43
Relativity .. 45
Differentiation .. 47
Everlasting Ignorance .. 49
Paired Opposites ... 51

The Weight of Sins	53
No Sweet in Sugar	55
After death	57
Function of humans	59
From praise to dispraise	61
Soul Case	63
Time and Tide	65
Intertwined Mind and Body	67
Constant Companion	69
Humanness in Marine	71
Didactic Lyric	73
It is a must	75
The ripe age	77
The Nature of God	79
The action of heart	81
Future homosapiens	83
Living with Literature	85
Negative source	87
Mother Earth	89

• This book is dedicated to those who are interested in reading books.

Author's Note

For many years, we have been living in this world doing various activities. Whether there is a purpose in our existence or not, we are living. Existence with humanness is important for humans. Feelings of humanity towards other fellow humans are essential in human culture. It is due to lack of this nature, we live a lifeless life. Life is not just pursuing education or getting a good job or marrying at a suitable time or bringing up children or saving wealth. Life is way of living without evil influence. It is only with divine's influence, one can lead a better life. Many people say that desire is the root cause of all problems. I would say that desire comes out of our ignorant mind. According to me, Ignorance is the cause of all problems. I do want to emphasize that one should have humanness as a basic quality. We have to introspect ourselves whether we have good thoughts because thoughts only decide our life and not material gains. Be a human rather than a man.

J.JOSEPH ANTONY

Sin Test

Sin Test

Is there any city without din?
Is there anyone without sin?
Sin makes a man sinner,
Testing sin makes God examiner,
Stone becomes an artful statue,
If artful heart is in the state of virtue,
Pearly gates of heaven for you,
Enter into the blithe place,
Avoid sin test which is against you,
Be in the God's palace.

The unaccountable Life

The Unaccountable Life

Life is pseudonym of materialism,
People, the victims of wealth building,
The brevity of life has got a few phases,
Child life moves with frivolity,
Youth life moves with lack of sensitivity,
Middle age life moves with cupidity,
Old age life moves with senility,
Life ends, wealth comes,
In the name of life, God uses
Man to build wealth.

Belongings

Belongings

Cloth that one wears belongs to him,
But the body does not,
Girl that one marries belongs to him,
But for a short time,
Wealth that a person owns belongs to him,
But until death,
Food that one consumes belongs to him,
But for some time, because
Everything belongs to God,
Though possess it.

Invention of God

Invention of God

No end to seek deity,
Though a few people not believing God,
No end to piety,
Though a few people are impious,
No end to worshipping multitude of Gods,
Though there is one God,
No end to the formation of abode of God,
Though God pervades everywhere,
No end to quest for God,
Though cannot see God.

Refusing Breathe

Refusing Breathe

Life is transient for all,
Problems are persistent to all,
Killing a self is a vain act,
Bud is for blossom not to wither,
Stop the selfish act,
Curb this personal disaster,
God who gives disease,
Gives medicine also, ponder,
Resist from the thought of suicide,
Desist from the act as inhuman.

A humanist

A humanist

Gandhi is a model of rectitude,
Many people follow his attitude,
A noble man of virtue,
Gandhi is a beacon light,
For those who want to fight,
A philanthropic by birth,
Non violence is his breath,
Perseverance is his path,
Independence is its fruit,
He is a superhuman creature.

Subordinated women

Subordinated woman

Widow, instead of wife,
Desolation is her life,
For women bliss occur,
For widow never recur,
Overshadowed by others as hapless,
Her soul mate went away,
Her nuptial knot taken away,
Lonely moon is attractive,
While it is waning,
Lonely widow is unattractive

Rapport

Rapport

Heat meets water above,
Water meets soil below,
Alliance is the goodness of nature,
Selfishness dominates human nature,
Music comes out of musical instrument,
Fame rests only on musician,
When benevolence comes out of you,
Shower of benefits for your heir,
Birds fly above through air,
Persons with benevolence always fair.

Shark and snail

Shark and snail

No loss to sea out of its fury,
No loss to wind out of its fury,
Loss for those who are wrathful,
Always be a discreet soul,
Abhor wrath as it is sinful,
Accept patience as a friend,
Control the emotion,
With determination,
Whenever there is fire,
Put it off before.

Connecting Waves

Connecting Waves

Man releases thought waves,
Sun releases radiation as waves,
Waves from man,
Waves from sun,
Both are same,
Man has sun's energy,
God exists in the form of energy,
Formless and nameless,
But waves connect,
Man and sun.

Valuable possession

Valuable possession

Waves persist in sea,
Humans can subsist with wisdom,
People pray the image of God as prime,
Seek wisdom as supreme,
Gold glittering makes it valuable,
For a house the facade is beauty,
For a human wisdom is nicety,
Person with wisdom one has to see,
No life for a rootless tree,
No respect for a spree.

The Real Beauty

The Real Beauty

Dainty child hearken a while,
Thou sprawl like an angel nicely,
Thou crawl like a crab smoothly,
Though thou bawl, calmness also lies,
Like a bonsai tree, thou look short,
Love your smile which is gorgeous,
Thou love to be bare, sweet of the dare,
Innocence brings relish, we cherish,
Thou are an ornament for your mother,
Fondling is an acknowledgement of beauty.

Invisible and indivisible

Invisible and indivisible

Joy associated with loving,
Cry associated with grieving,
Frightening associated with fear,
Scolding associated with anger,
On the left, the bodily expressions,
On the right, the emotions,
Though visible and invisible,
Both are inseparable or indivisible,
Like the soul and mind,
Both are Invisible and indivisible.

Unchanging Love

Unchanging Love

Cloudy sky bears water that descends but,
My mother bears me at heart,
Time goes on, there is no end,
The mind is full of kind,
Never think of wealth,
Because the image gives me strength,
What oblation can I give you?
When a ship sinks in the sea,
There is no harm for fish but,
When you die, I will perish.

Emotions of Teens

Emotions of Teens

Nothing known but grown,
Their actions cause frown,
It is a period to shine,
Their appearance is always fine,
Blissful life they want to lead,
Passing pleasure they have to heed,
Reluctant to read,
So guide is a need,
Like a seed,
He has to nurture the teens.

Beneath Trees

Beneath Trees

Jungle life, I want to live,
The breeze of wind which is rare,
Trees with sylvan hive,
Green shelter everywhere,
Numinous, Love to have food,
Among the wood,
Like death, we forget,
We too partly animal,
A thinking animal,
It is also a speaking animal.

Sacred house

Sacred house

A house filled with roses,
Not worried for parentless,
No feeling of sigh,
Being under God's clutches,
So it is a sacred house,
Real life is only in unity,
Here, there is no diversity,
Orphan house, a symbol of unity,
Free from society,
It is a holy community.

Relativity

Relativity

Primitive man is our relative,
Dynamic kind,
Though separated we are all relatives,
Dexterity mind,
We fix a few as our relatives,
A few as our friends,
After marriage a girl becomes relative,
Why not a child as relative?
Like a girl, adopt a child because,
All are relatives with respect to spirit.

Differentiation

Differentiation

God loves the word differentiation,
So created a world with inequality,
Humans do not understand his creation,
So blame God for his partiality,
Look at the perfection,
In creating a world with amenity,
Inequality is a strategy,
That causes vivacity,
We see the differentiation,
And there is no mendacity.

Everlasting Ignorance

Everlasting Ignorance

There is sun that never rises or sets,
It seems so,
There is man but no high or low class,
It seems so,
Ignorance remains within man,
Like the position of sun,
Educated or uneducated,
Ignorance can never be removed fully,
Because it is created skillfully,
So it is ever lasting.

Paired Opposites

Paired Opposites

Heaven hell which are unseen,
Rich poor which are made,
Water fire which are seen,
Joy sorrow which are formed,
Physically, strong and weak,
Mentally, intelligence and foolish,
Emotionally, love and hatred,
Sweet bitter with regard to tongue,
Dry wet with regard to land,
Mystery of creation lies in paired opposites.

The Weight of Sins

The Weight of Sins

A speedy being with feelings,
Indulged in wrong deeds,
That resulted in saving of sins,
That being continued the deeds,
That resulted in sufferings,
That being never realized the fact,
It bears the sins of ancestors also,
Once that being sees a stoic,
And learnt to control emotions,
Become aware of sins.

No Sweet in Sugar

No Sweet in Sugar

Development has been progressive,
Though it is regressive,
No sweet in the sugar,
Nature is in danger,
City life is awful,
Working condition that is so stressful,
Pandora's Box is development,
Development brings destruction,
Like binary opposition,
We do a lot to make life prosperous,
But the effects are numerous.

After death

After death

Soul that is wrapped goes away,
Body which is with us starts decay,
Soul is a substance,
A form of God's presence,
Soul is related to character,
That remains forever,
Like the salt of sea water,
If soul cannot be destroyed,
Would not the soul come again?
Life comes after death,
There is life after death.

Function of humans

Function of humans

At the outset, a little body,
Growth makes to study,
Time has come to do duty,
Period for marriage is ready,
Life with happiness goes,
Children come to look after,
Time with perfection passes,
Sans job hereafter,
Waiting for the creator,
Since, Life is over.

From praise to dispraise

From praise to dispraise

A submissive damsel,
Thinks of an espousal,
She likes a clerk, not dark,
Happy with a virtuous man,
He becomes a leman,
No ire, only lenity,
That shows her chastity,
But finally nags the soul mate,
For being unman, no fruit,
Dolor touches her.

Soul Case

Soul Case

Appearance that is primate
Essence is soul to activate,
Internal structure is so rigid,
Surrounded by a soft substance,
Circulated by a fluid,
Operated by a few organs,
Has a natural dress to cover,
Everything is intact to act,
Soul case carries what?
Like a suitcase.

Time and Tide

Time and Tide

Time is a key factor,
To move up as an escalator,
Those who are prim,
Followed time with firm,
God considers time and action,
Auspicious time, begin an occasion,
By wasting time, we fail to sail,
Good things happen in good time,
Good to sing a rime on time,
It is time that decides our life.

Intertwined Mind and Body

Intertwined Mind and Body

Androgynous mind humans mind,
Andro that belongs to men,
Gyno that belongs to women,
Found in every individual's mind,
Show Human mind is intertwined,
Appearance wise one can behold it,
That is effeminate nature in man,
Testosterone which is in men's testicles,
Is also in women's ovaries,
Show Human body is intertwined.

Constant Companion

Constant Companion

A good companion becomes a constant companion,
Miracles would happen with its union,
Words as Holy Scripture,
Those words make people rapture,
Following the words would purify souls,
Lead us to the path of salvation,
There will be no reincarnation,
There will be no senseless life,
God's tool is this companion,
Let the Holy Bible be the constant companion.

Humanness in Marine

Humanness in Marine

Feeling of jealous within us,
That separates us from others,
Feeling of prejudice is a curse,
That is a repulsive force,
God is the only driving force,
God could be a stone,
Could our heart be a stone?
In marine, in the absence of humans,
Dolphin rescues humans from danger,
Dolphin is a silent teacher.

Didactic Lyric

Didactic Lyric

Moral in eyes, if lies,
Moral in lips, if comes,
Moral in action, if happens,
These moral acts,
Would reflect in our body,
This is the influence of morality,
No need any jewel,
The jewel is moral,
God looks only at moral,
Not jewel.

It is a must

It is a must

Barbarians our ancestors,
Hunted only animals,
Mind where intellectual rests,
Made barbarians to think,
Their minds cultivated,
As time progresses,
Through various sources,
Began to act wisely,
Their minds civilized,
Education is Cultivation of mind.

The ripe age

The ripe age

Old age is fragile,
Due to the absence of agile,
Caring is expectable,
For being senile,
Ripened fruit must fall,
That is common for all,
This age is a gift,
Though there is no swift,
Waiting for clinical death,
Don't want to live like a sloth.

The Nature of God

The Nature of God

The Nature of God is Pleroma,
It is not an enigma,
Not man's ingenuinity of dogma,
One lives in his own house,
The universe is created by God,
So it is God's dwelling place,
With the space,
Stars and planets,
Irrespective of the size of the objects,
The Universe is nothing but God.

The action of heart

The action of heart

Heart is dynamic,
Other organs are static,
Heart palpitates,
Sign of the jitters,
Though it is disturbed,
It functions well,
Palpitations last for a while,
But, Human should always,
Be a hectic human,
Like the palpitations of heart.

Future homosapiens

Future homosapiens

Life for homosapiens is certain,
With regard to futurity,
But livelihood is uncertain,
When we consider the posterity,
Emaciated condition would occur,
The ability to withstand may suffer,
The world would be chaotic,
Catastrophe will often occur,
Homosapiens will be in peril,
Even now things are vanishing.

Living with Literature

Living with Literature

Land is beautiful,
Because of pasture,
Life is meaningful,
Because of literature,
Human mind is imperfect,
Deep but dark,
Studying literature which,
Makes man human,
Modern Culture,
Need to live with literature.

Negative Source

Negative source

Charge of electron is negative,
Its action is active,
Electrons bring goodness,
When it comes to electronics,
Electrons can also spoil objects,
When it comes to psychotronics,
Energy from psyche affects,
All living organisms,
Including plants and animals,
Negative source is within our body.

Mother Earth

Mother Earth

Earth is misused,
Unusual events one can see,
Deeds against nature can be observed,
As a result, we face the eustasy,
We feel the fervent earth,
Since humans are fallen beings,
Again greed has played,
As a result, Earth is buried,
People failed to do their devoir,
That is protecting the earth as their mother.

www.ingramcontent.com/pod-product-compliance
Lightning Source LLC
Chambersburg PA
CBHW022123170526
45157CB00004B/1730